THE GREAT MASTERS OF DRAWING

DRAWINGS BY

TINTORETTO

BY

GIUSEPPE DELOGU

TRANSLATED BY

CLARA BARGELLINI

DOVER PUBLICATIONS, INC., NEW YORK

Published in Canada by
GENERAL PUBLISHING COMPANY, LTD.,
30 LESMILL ROAD, DON MILLS, TORONTO, ONTARIO.

Drawings by Tintoretto is a new translation first published by Dover Publications, Inc., in 1969, of the work first published by Aldo Martello, Milan (n.d.), in his series "I Grandi Maestri del Disegno." The present edition, which contains all the original illustrations, is published by special arrangement with Mr. Martello.

Library of Congress Catalog Card Number: 68-27838

Manufactured in the United States of America

DOVER PUBLICATIONS, INC.
180 VARICK STREET, NEW YORK, N.Y. 10014

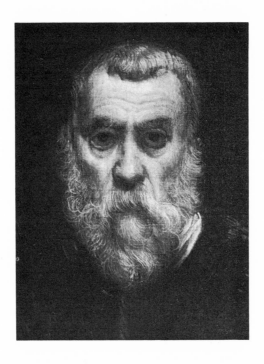

TINTORETTO'S DRAWINGS

Ohne den Schlüssel der vorbereitenden Zeichnungen ist Tintoretto als Maler nicht ganz zu verstehen.
(Without the key provided by the preparatory drawings Tintoretto the painter cannot be fully understood).

HADELN.

THE CONCEPT and practice of drawing are doubly individual phenomena in the art of Jacopo Robusti. This is first because they determine the character of his painting and of his figurative language, and second because they distinguish him, a very Venetian artist, from the splendidly developing Venetian tradition, begun a century before his time. No matter how the concept of drawing and the practice of drawing are understood, Tintoretto, who was dominated by the one and warmly dedicated to the other, will always be considered a master of the art.

Begin with the esoteric definition of Pliny, who, speaking of the contour of bodies (*extrema corporum*) and of the exterior rhythm of a figure, considers how rarely the two are found together in art. Pass on to Cennini's late fourteenth-century precept: "The foundation of art ... It is good for you to have the discipline to begin to draw as well as possible" (*Libro dell'Arte*). Reach the most advanced considerations of Leonardo on the absence of line (*non-linea*). Listen to Michelangelo's judgment: "Drawing, the following of contours or whatever we might wish to call it, constitutes the source and substance of painting, of sculpture, of architecture and of all the other kinds of art, and is the root of all the sciences" (note in these last words the influence of Leonardo's concepts of method). Every definition, precept, consideration or judgment can be found in the art of Tintoretto. His living and sensitive experience as an artist seems to agree partly with Varchi, who wrote: "The first drawing is the invention of the entire imagined universe ... in the mind ... before it becomes act in relief and in color." Intellectual, romantically sentimental, physical-experimental aspects are all present, often simultaneously, in Tintoretto's method of drawing. For him drawing can be

the first and then the progressive analysis of things, the first approach to the objective world, a study of structures; or a rapid synthesis of images, of sudden apparitions; figures from life or posed, or startling reflections of an interior reality.

At any rate, drawing was the law and revelation of Tintoretto's aesthetic creed, which might make him seem the least Venetian of the Venetian masters of the sixteenth century. He was "fiercely convinced" of this—something which Vasari neither saw nor understood. Instead, as a good Tuscan who had always criticized the failings of Venetian draftsmanship, Vasari said of Tintoretto that he would "sometimes present as finished works sketches which are such mere outlines that the spectator sees before him pencil marks made by chance, the results of bold carelessness rather than the fruits of design and of well-considered judgment." On the whole, Tintoretto did not have a good press in his lifetime; just as today not all of his work is acclaimed. Even Aretino, who was the only one to defend him, often misunderstood him. He once noted: "Your name would be blessed if you would convert the promptness of the result into patience during the execution."

Just as they did not understand the prophetic modernity of his work, these critics did not see the case of aesthetic conscience which was anchored in Tintoretto (one can certainly speak thus, considering that stormy sea which is his world). Tintoretto's aesthetic was anchored in the rules of drawing: in drawing he found measure and discipline, joy and the sweat of labor and conquest. His scrupulous attention to a study which was tireless, unending, the study of drawing, escaped his contemporaries, who speak of "boldness" and "promptness" as if they were synonyms for carelessness.

Yet, as a young apprentice, as an independent artist and as a mature master, Tintoretto was always drawing. He would draw from statues, from casts, from constructed models or from live models. And yet to the testimony of Borghini and of Ridolfi (who speaks of an "infinite number of drawings"), to the affirmations of Boschini (*Carta del navigar, Ricche miniere*) about the collection of sculptures that were in the master's study, has been preferred the facile little formula, certainly apocryphal, which was supposed to have been written as a motto or reminder on a wall of his studio: "The form of Michelangelo, the coloring of Titian." The more authentic tradition of an anecdote referred to by Ridolfi himself is forgotten: asked by the Bolognese Fialetti how to begin to educate oneself in painting, the master, already old, advised, "Draw, draw, and draw still more." Beautiful colors can be learned at the Rialto, it seems he used to say, but the art of drawing can be created only through tireless study. His vocation, his passion and his reason were in agreement on the principle of drawing. Because of this he is the most Manneristic of the Venetians; yet he remains among the first of the great Cinquecento painters. At no moment of his creative ardor does he ever cease to be a painter who achieves equilibrium of form, tone and color and a successful chromatic-plastic synthesis.

Tintoretto remains a painter while he draws, even though the linearism and attention to contours, the motion of short and long curves in his compositions and an individual "prosody" establish differences and distances from the plasticity and the "color" of the drawings by contemporary Venetians like Titian and Veronese. Yet these elements create an intense and lyric poetry of the drawing in itself. Poetry and reason in drawing become a constant in the art of the master. This is not only because of the continual and immediately observable interdependence of drawing and painting (in fact, Hadeln has been able to affirm that in drawing is the key to the preparation of the paintings). It is also because the continual exercises of drawing became mastery and the precious sheets became works important in themselves. Drawing is especially a constant of his art if we consider that there seems to be no evolution in the forms and in the style of his drawings as there is in his paintings. It is barely possible to order chronologically the drawings from the forty years of his activity because of the near homogeneity of the use of chiaroscuro and because of the occurrence of the same techniques throughout. It would in fact be impossible to give any order at all to the

drawings were it not for the references to the *teleri* (extensive narrative cycles in oil) or the documentation of dated or firmly datable paintings.

Formed in the Manneristic Florentine tradition which had penetrated into Venice, Tintoretto practiced drawing from his youth, when, according to the story, the aged Titian drove him out of his studio because of suspicion and jealousy. But he was always a painter; so much so that, paradoxically, we can sometimes feel the Michelangelesque forms which he knew and loved through the mediation of a Titianesque creation, as in the painting of *Cain and Abel*. For the love of drawing and of form he took up those "compositional, narrative and dramatic values which were the sinews of Florentine Mannerism," "which the triumph of Giorgionism had eclipsed." But even while drawing he remained a painter with that *goût de couleur* which Mariette had noticed only in drawings by Giorgione.

A dramatic painter, whose impulses are irresistible, he conceals the order ultimately dominating each creation through the discipline of drawing. He is like an improvising speaker, with a perpetual *ex abrupto*, whose eruptions and impetus have had the help of a few notes, of a few loose sheets. But these notes are pulsating witnesses of feverish activity. These testimonial sheets are relatively few considering the endless horizon of his creations. It is thus surprising that he did not use (or that we have not found) large *bozzetti* (elaborate preliminary drawings) to build his superb scenes and to construct such large complexes as he did. If from the sketch he passed directly to the large canvas, it can only mean that microcosm and macrocosm were equivalent in his imagination; in the aesthetic intention they were of the same blood. The network of squares superimposed on many of the sheets means that the drawing was translated immediately into painting, a procedure unknown to other masters, who passed through several stages between the first ideas and the final composition. The absence of the *bozzetto* for Tintoretto is equivalent to the absence of the full-size model for Michelangelo. It is not only *terribilità* which constitutes the elective affinity between the two giant spirits. Just as no models are known for the Medici tombs or for any of the great sculptural creations of Michelangelo, no *bozzetti* are known for the paintings of Tintoretto (the *bozzetto* for *The Carrying Away of the Body of St. Mark* in Brussels is considered not authentic or of Tintoretto's school, perhaps; at any rate, late).

The absence of intermediate *bozzetti* and of complex trial pieces closer in size to the finished original has led some to suppose that the master used a very singular approach of his own. The sources refer to this, particularly Ridolfi. Hadeln and Pallucchini (and we) accept the theory. The supposed method of working corresponds to the character of the result, to the *mise en scène* and to the theatrical effect, if one wants to call it that, which a master of spaces and a celebrated expert at perspective and illusionism like Tintoretto could achieve. He visited places to recreate in his study small scenographic models within which he moved the figures. Within the space he arranged "small models in wax or clay" and he suspended mannequins in active poses.

This artificial ensemble was "photographed" by his mind, which adjusted the illumination according to its own taste for chiaroscuro, with lighting effects recalling the Mannerists and Michelangelo. These effects also proved to anticipate the luministic drama of the seventeenth century. The puppets became masses, shadows and spots in his imagination. Then the single figures were studied from life. The stage collapsed and was blurred. The characters were then free to be created with verification from living models. Although they were to serve the finished painting as a whole, living beings remained individual and autonomous persons. The study of the body and of the drapery was found to be necessary, but first and always came the structure, the anatomic architecture, which was then dressed. We feel that the lightness of the drapery or the strength of the metal armor clothe, but do not cover and obstruct, the human person in its dignity, in its life. In this principle also Tintoretto is related in spirit to Michelangelo. The human figure, man, dominates the "map" of his figurative

3

world. At San Rocco a new poetry, this time of landscape, reveals itself; in a panorama of valleys and of hills, gigantic trees are evoked from the shadows of dusk by sprays of light and flashes of flame. The Maries—Mary of Egypt and the Magdalen—are humble shepherd-esses just barely marked by phosphorescent aureoles. These sheets over which passed the feverish, nervous and creative traces of charcoal and of crayon, on which chalk and white lead here and there ably illuminated the forms of a world in monochrome—yet distinctly colored by the modeling with lights and darks—have as their protagonist man studied in his natural muscle and bone structure, in his nudity. The intent of the study of the nude is in itself constructive. The final use of the model is dynamic: no canons, nor searches for super-ficial beauty, nor exercises in beautiful calligraphy; instead, an impulsive script from a hand which does not want to be chic, a hand without easily flowing grace, but rather with strength of will, with an excited imagination constrained to a welcome task.

After these observations, the attempt to give a chronological order to the precious sheets of drawings is difficult, if not impossible. First Hadeln, and now Tietze, have expressed their valuable opinions. For some drawings there is not just a disparity in the decades to which they are assigned, but indeed in the periods. For example, the famous sketch in the Berlin Kupferstichkabinett, No. 4193 (one of the very rare *schizzi-bozzetti*, perhaps the only one), which was preparatory for the Munich Pinakothek painting of *Venus and Vulcan*, is con-sidered by many a youthful work. Some, however, date it between 1570 and 1580, thus moving it ahead by thirty or forty years.

All can agree that since there are no early documented works for the first decades of Tintoretto's activity when he was a pupil in Titian's studio and was under the influence of Tuscan Mannerism (Daniele da Volterra, Jacopino del Conte, Cecchin Salviati, and in the Venice area Pordenone, Bonifazio Veronese, Paris Bordone; see the studies of G. Fiocco and R. Pallucchini), the *Pietà* (738), the *St. Martin* and the *Flagellation* (Plates 1 and 2) of the Uffizi must be considered among his earliest paintings. From these works of 1565–70 one can move to the stupendous study for *The Washing of the Feet* in Santo Stefano in Venice, executed after 1581. This sketch, although it is more complex and tormented because of the tangled traces seeking several profiles and thus resulting in an agitated and trembling line, cannot be distant from, and follows in time, the studies for the *Baptism* in the Church of San Silvestro in Venice. Firmly dated in the fifth decade of the century are *The Last Supper* of San Marcuola, 1547, *The Miracle of the Slave*, 1548, and the San Marziale altarpiece, 1549, all in Venice. *Arsinoe*, the *Susanna* of Vienna and a couple of portraits follow with less certainty.

There are no certain drawings which correspond to extant paintings executed after 1560. For various reasons, however, the studies after statues and those directly inspired by the works of Michelangelo must be assigned to the years between 1550 and 1560. There exists, besides, a group of related drawings; related not only in spirit, but also in technique, style and taste. Softness of modeling and a greater sense of plasticity are used to interpret the plastic, statue-like values of Michelangelo with painterly sensibility. These are drawings in museums in Bayonne, Oxford, Frankfurt and Florence and in the Louvre (Plates 3–9). Some of these, like the study for *Samson and the Philistines* (Plate 3), and the one from a model for the *Giuliano* of Michelangelo, have a character of completeness, of *finito*, in the determined profiles and in the relief which seems to be forced by the touches of white lead. These traits are not easily found elsewhere, and more than to any of the other drawings the designation "study" can be applied to these.

This is the period of the most efficacious Manneristic influences. Tintoretto's fancy turns to classic or classicizing statues, of which models, copies, casts and drawings decorate his studio. Boschini and others speak of this collection, among which was a *Laocoön*, a *Medici Venus*, a *Farnese Hercules*, busts of emperors, groups by Giambologna (whose taste recalls in fact Tintoretto's own *Samson*) and finally the models (or the drawings) of Michelangelo's

work for the Medici tombs. These had become known in Venice when Vasari sent Aretino the first drawings made after the statues in 1535; Tintoretto was then about seventeen years old. It is absurd to think he saw those drawings immediately. On the contrary, it is evident that his own studies are from three-dimensional models, from plaster casts, perhaps those same casts which Daniele da Volterra had first made known. He had used them for his *Massacre of the Innocents* at Santa Trinità dei Monti in 1550, according to Vasari. By 1557 they were certainly also in Venice. There is, further, the possibility of direct knowledge of the work of Michelangelo through a rather probable trip to Rome, with a stay in Florence, which Tintoretto could have made between 1545 and 1555.

What is certain is that these superb drawings, with intrinsic value as art, are also precious confessions of the master in their moving testimony to his affections, his predilections, his ideals and his veneration for the awesome old man of the Sistine. They are more. Since the famous frescoes of the exterior of Venetian houses (like the celebrated ones by Giorgione and Titian on the Fondaco dei Tedeschi) are irretrievably lost, there remains only the memory recorded by A. M. Zanetti (see the Bibliography) of Tintoretto's frescoes for the Casa Gussoni, considered youthful work by Ridolfi. Now, in those frescoes Tintoretto had not pictured things of Venetian taste or inspiration, as might have been more obvious than easy to suppose, especially with the famous examples of his great contemporaries or of Giorgione still visible; but had pictured instead *Dawn* and *Twilight*, as the engraving in Zanetti's book attests, and as the still extant studies by Tintoretto confirm.

Besides the bust of Vitellius, which is part of this group, the studies after Michelangelo make up a notebook of some ten leaves, recto and verso, thus some twenty drawings. They are found in the previously mentioned museums (that is: Oxford, Christ Church L. I, recto and verso; L.1, recto and verso; L.3, recto; L.4; L.5, recto and verso; in Berlin, Kupferstichkabinett, Nos. 5228, 5736; in Florence, Uffizi, 13048, recto and verso; 1840, recto and verso; Paris, Louvre, 5384; and for the antique statues: Oxford L.8, recto and verso; Munich 2982; Florence, Uffizi, 13008).

After the experience of these drawings comes a group which can be convincingly dated within the 1560's: the two soldiers throwing dice (Plate 10), a study for a detail in the right-hand part of the painting of *The Crucifixion* in the Accademia in Venice; a servant with an amphora (Plate 11) for a figure in *The Wedding Feast at Cana* in the Church of Santa Maria della Salute in Venice, signed and dated 1561; a study for a seminude figure for *The Worship of the Golden Calf* of the Madonna dell'Orto (Plate 12); the superb studies (Plate 13) with vague compositional intent for *The Washing of the Feet* in the church of Santo Stefano in Venice (by some dated after 1581), contemporary with the studies begun for the Scuola di San Rocco, like the one of a nude for *The Way to Calvary* (Plate 14); a female nude for the Eve of the *Christ in Limbo* in San Cassiano, Venice (Plate 15); the two studies for *The Baptism of Christ* in the Church of San Silvestro in Venice, one for St. John (Plate 16) and the other for Christ (Plate 17).

Not precisely datable but singularly dense and full of chiaroscuro texture are the drapery study of the Galleria Corsini (Plate 18), obviously recalling the taste of Veronese, and the study for a *Kneeling Bishop* of the Uffizi (Plate 19), which is closer to the manner of Titian. The same sense of plasticity in the drapery is seen in the study for a *Philosopher* in the Biblioteca Marciana (Plate 20) of about 1570-75, as well as in the studies of nudes in the Uffizi (Plates 21 and 22) with their vibrant, coiling movement of line, and the Christ at the Column for the *Flagellation* in the Kunsthistorisches Museum in Vienna (Uffizi; plate 23) and the nude in the Landesmuseum of Darmstadt (Plate 24). The study of a man running (Plate 25) achieves a convincing effect of motion, while the costumed model (Plate 26) assumes a static pose. This latter drawing is useful for observing how—to a greater degree than is normally seen—the human body is studied in the nude and then dressed in clinging drapery. The study of a man

in armor (Plate 27) for the painting of *The Investiture of G. F. Gonzaga* in the Munich Pinako-thek (the first figure on the right), in the means used to render the form and reflections of the breastplate with pictorial indecision, offers instructive comparisons with similar essays, differently resolved by Titian and by Paolo Veronese in their well-known studies of armor. Because of the singular vigor of line and the effects of dynamism, it seems to me that the drawing of a *Warrior* in the Uffizi (Plate 28) and that of a *Rower* in the Galleria Corsini in Rome (Plate 29) must be placed at this point.

From 1581 to 1584 and from 1584 to 1587 Tintoretto was working on the paintings for the Doges' Palace. For *The Battle of Gallipoli*, on the ceiling of the Sala del Maggior Consiglio, there are drawings like that of the standard-bearer (Plate 30). For *The Battle of Zara*, on the left wall of the Sala dello Scrutinio, the artist prepared numerous studies, among the most lively and powerful that he has left to us. He was by this time in his seventies. The aged man was already meditating the paradisiacal vision, the supreme synthesis of his thought, consecrated in the majesty of the Sala del Maggior Consiglio in 1588.

After the work at San Giorgio, he found peace and burial in his pantheon, the Madonna dell'Orto, on May 31, 1594.

1518 Between September and October, not in 1512 (Ridolfi) nor in 1524 (Borghini), Jacopo Robusti is born in Venice. His father was of Lucchese origin and a dyer (*tintor*) of cloth, hence the nickname Tintoretto.

1539 He becomes a free and independent master, "Mistro Giacomo depintor."

1545 A letter from Aretino thanks the master for two ceiling paintings, *Apollo and Marsyas* and *Argus and Mercury*. The former is perhaps in London, Bromley-Davenport Collection (Hadeln, Tietze, Coletti); the latter is lost.

1546 *Feast at the House of Balthasar*, fresco on the façade of the Casata dei Fabbri at the Arsenale, dated by Ridolfi to 1536; now vanished.

1547 *Last Supper* of San Marcuola.

1548 *Miracle of the Slave* for the Scuola Grande di San Marco, Venice Accademia; two letters of Aretino, April 1548.

1549 San Marziale altarpiece (final payment December 4).

1550 Beginning of the paintings for the Scuola della Trinità, now partly in the Accademia, Venice.

1550 (circa): He marries Faustina de'Vescovi.

1552 *Evangelists and Saints*, now in the Accademia, Venice.

1553 *Excommunication of Frederick Barbarossa* for the Doges' Palace, destroyed in the fire of 1577.

1556 Final payment for the organ doors in the Madonna dell'Orto (commissioned 1548 and 1551).

1559 Payment from the Scuola di San Rocco for the doors to the silver cabinet.

1559–60 *Pool of Bethesda* in the Church of San Rocco.

1561 *Wedding Feast at Cana* in the Church of Santa Maria della Salute, Venice.

1562 Paintings for the Scuola del Santissimo of Santa Maria Mater Domini; *Coronation of Barbarossa* (destroyed in the 1577 Doges' Palace fire).

1564 Work begins at the Scuola di San Rocco.

1565 *Crucifixion* at the Scuola di San Rocco.

1566–67 The decoration of the Sala dell'Albergo of the Scuola and of the Church of San Rocco is finished; he is named

as a member of the Florentine Academy; *Judgment* in the Sala dello Scrutinio of the Doges' Palace (destroyed in the 1577 fire).

1568 Cartoons for the mosaics of San Marco; *Christ in Limbo* of San Cassiano.

1571–75 Paintings for the Biblioteca Marciana.

1572–74 *Battle of Lepanto* for the Doges' Palace (destroyed in 1577).

1575–81 New work at the Scuola di San Rocco.

1578 Four allegorical mythological paintings in the Anticollegio at the Doges' Palace.

1584–87 *Battle of Zara*, Sala dello Scrutinio, Doges' Palace.

1588 *Paradise*, Sala del Maggior Consiglio, Doges' Palace.

1590 Death of Marietta Robusti.

1592–94 Work at San Giorgio Maggiore.

1594 (March 30): Last will and testament.

1594 (May 31): Death of the master. He is buried in the tomb of the de' Vescovi family in the Madonna dell'Orto.

(For this chronological table, see especially the books of A. Venturi, Tietze and Coletti in the Bibliography.)

BIBLIOGRAPHY

A / GENERAL

VASARI, G.
Le Vite (2nd ed., Milanesi), Florence, 1881. VI, 1568.

SANSOVINO, F.
Tutte le cose notabili, Venice, 1561–83, 1861.

BORGHINI, R.
Il riposo della pittura e della scultura (1st ed. 1584), Milan, Società tipografica dei classici italiani, 1807, 3 vols.

RIDOLFI, C.
La vita di G. Robusti, Venice, 1642.

BOSCHINI, M.
La carta del navigar pittoresco, Venice, 1660.
Le miniere della pittura veneziana, Venice, 1664.
Le ricche miniere, Venice, 1674.

ZANETTI, A. M.
Varie pitture a fresco dei principali maestri veneziani, Venice, 1760.
Della pittura veneziana, 1771.

GALANTI
"Tintoretto," *Atti dell'Accademia di Venezia*, 1876.

STEARNS, P.
Life and Genius of Tintoretto, New York, 1894.

BERENSON, B.
The Venetian Painters of the Renaissance, New York, 1911.

THODE, H.
Tintoretto, Leipzig, 1901.

HOLBORN, S.
J. Robusti Called Tintoretto, London, 1907.

SOULIER, G.
Le Tintoretto, Paris, 1912.

OSMASTON, F. P. B.
The Art of Genius and Tintoretto, London, 1915.

PITTALUGA, M.
Il Tintoretto, Bologna, 1925.

BERCKEN, E., AND MAYER, A.
Il Tintoretto, Munich, 1923; new revised ed. 1942.

BERCKEN, E.
In Thieme-Becker, *Allgemeines Lexikon der bildenden Künstler* (*ad vocem*), Leipzig, 1939.

LORENZETTI, G.
Guida di Venezia, Milan, 1927, Introduction and *passim*.

VENTURI, A.
Storia dell'arte italiana, IX, iv & 403–623, Milan, 1929.

MOSCHINI, T.
1931; *La mostra del Tintoretto*, catalogue, Venice, 1937.

COLETTI, L.
Tintoretto, Bergamo, 1940; 2nd ed. 1942.

TIETZE, H.
Tintoretto, the Paintings and Drawings, London, 1948.

PALLUCCHINI, R.
La giovinezza del Tintoretto, Milan, 1951.

B / SAN ROCCO

RUSKIN, J.
The Stones of Venice, III, 184–306, London, 1907.

NICOLETTI
Illustrazione della chiesa e scuola di S. Rocco in Venezia.
Miscellanea della deputazione di storia patria di Venezia, Series IV, Vol. III, 1885.

VON DERSCHAU, J.
Zum geistigen Gehalt der Gemälde Tintorettos in der Scuola S. Rocco, Heidelberg, 1911.

PITTALUGA, M.
"Di alcune tracce sul verso della *Crocifissione* del Tintoretto nella S. di S. Rocco," *L'Arte*, 1921.

BERLINER
"Die Tätigkeit Tintorettos in der Scuola di S. Rocco," *Kunstchronik*, March 1920, 468–73, 492–97.

OJETTI, U.
"L'arte del Tintoretto," *Venezia*, August 1927.

BRUNETTI, M.
La scuola grande di S. Rocco.
La scuola grande di S. Rocco in Venezia, Venice, 1927.
Nel VI Centenario della morte del Santo patrono (essays by R. Molmenti, R. Bratti, G. Lorenzetti, M. Brunetti, A. Tursi and others).

DELOGU, G.
Tintoretto alla Scuola di S. Rocco, Bergamo, 1936; 2nd enlarged ed. 1951.

PALLUCCHINI, R., AND BRUNETTI, M.
Tintoretto a S. Rocco, Venice, 1937.

C / THE DRAWINGS

A bibliographical note on Tintoretto's drawings is contained in an as yet unpublished work by R. Pallucchini (Bergamo, Istituto Italiano d'Arti Grafiche) which was consulted while still in the proof stage through the courtesy of the author. We refer to that note and make some additions, especially of works published between 1939 and 1952.

COLVIN, S.
Oxford Drawings, II, cited by Hadeln.

HADELN, D.
"Zeichnungen des Tintoretto," *Jahrbuch der preussischen Kunstsammlungen*, 1921.

BORENIUS, T.
"Old Master Drawings at South Kensington," *Burlington Magazine*, XXXIX, 1921, 224.

HADELN, D.
Zeichnungen des Giacomo Tintoretto, Berlin, 1922.

FROEHLICH-BUME, L.
"Some Unknown Venetian Drawings in the Louvre," *Burlington Magazine*, XVIII, 1923, 28 ff.

MAYER, A. L.
"Tintoretto Drawings in the Louvre," *Burlington Magazine*, XLIII, 1923, 33–34.

HADELN, D.
"Some Drawings by Tintoretto," *Burlington Magazine*, XLIX, 1924, 278–84.
Old Master Drawings, I, 1926, Plate 25.
"Some Paintings and Drawings by Tintoretto," *Burlington Magazine*, XLVIII, 1926, 115–16.

DUSSLER, L.
"Two Unpublished Drawings by Giacomo Tintoretto," *Burlington Magazine*, LI, 1927, 32.

HADELN, D.
"Zwei Zeichnungen Tintorettos," *Pantheon*, II, 1929, 421–22.

CLARK, K.
"Venetian Drawings in Windsor Castle Library," *Old Master Drawings*, 1931, Plates 44–46.

DOBROKLONSKY, M.
"Some Unknown Drawings by Tintoretto in the Hermitage," *Apollo*, 1932, 147–49.

PROTTI, R.
"Tre disegni del Tintoretto scoperti a Salisburgo," *Rivista di Venezia*, 1933, 81–84.

TIETZE–CONRAT, E.
"Echte und unechte Tintoretto-Zeichnungen," *Die Graphischen Künste*, 1936, 88–100.

DEGENHART, B.
"Zur Graphologie der Handzeichnung," *Kunstgeschichtliches Jahrbuch der Bibliotheca Hertziana*, 1937.

MORASSI, A.
Disegni antichi della collezione Rasini in Milano, Milan, 1937.

TOZZI, R.
"Disegni Inediti di Jacopo Tintoretto," *Bollettino d'Arte*, January, 1937, 318–21.

Besides the general works cited above under Coletti, Tietze and Pallucchini, see Tietze-Conrat, *The Drawings of the Venetian Painters in the 15th and 16th Centuries*, New York, 1944; and G. D'Albanella, *Venetian Drawings of the XV–XVIII Centuries*, The Hague, 1950.

For some considerations on Venetian drawing, see G. Delogu, *Disegni veneziani del '700*, Milan-Zurich, 1947.

For a general history of drawing, see the fundamental work: L. Grassi, *Storia del disegno*, Rome, 1947 (for Tintoretto, pp. 57 and 129 and Plate XXXVII).

LIST OF PLATES

Self-portrait (illustration, p. 1)

1 St. Martin and the beggar

2 Study-sketch for a *Flagellation of Christ*

3 Study for a group of *Samson and the Philistines*

4 Study of a model for the *Giuliano de' Medici* of Michelangelo

5 Study of the head of the *Giuliano de' Medici* of Michelangelo

6 Study of a head said to be of Apollo

7 Study after a sculpture

8 Study after the *Twilight* of Michelangelo

9 Study after the *Day* of Michelangelo

10 Study for the soldiers throwing dice in the Accademia *Crucifixion*

11 Study for a figure in *The Wedding Feast at Cana*

12 Study for a nude in *The Worship of the Golden Calf*

13 Study for *The Washing of the Feet*

14 Study of a nude for *The Way to Calvary*

15 Study for the Eve in the *Christ in Limbo*

16 Study for the St. John in *The Baptism of Christ*

17 Study of a nude for the Christ in *The Baptism of Christ*

18 Study of drapery

19 Study for a *Kneeling Bishop*

20 Study for a *Philosopher*

21 Study of a nude

22 Study of a nude

23 Study of a nude for the Christ at the Column in the Vienna *Flagellation of Christ*

24 Study of a seated nude

25 Study for a running figure

26 Study of a costumed model

27 Study for a man in armor in *The Investiture of G. F. Gonzaga*

28 Study for a *Warrior*

29 Study for a *Rower*

30 Study for the standard-bearer in *The Battle of Gallipoli*

31 Archer, study for *The Battle of Zara*

32 Archer, study for *The Battle of Zara*

I

St. Martin and the beggar. Charcoal on light grey paper; 400 × 242 mm. Perhaps a sketch for the altarpiece on the same subject in San Martino di Murano. Bibl.: Hadeln, pp. 31, 51, Plate 14; Tietze, CXIII, 3.

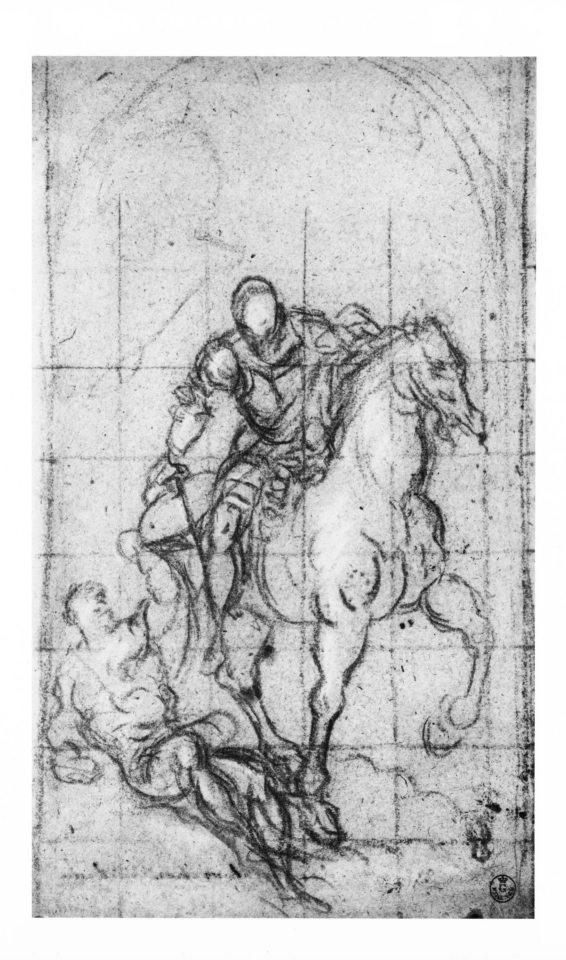

2

Study-sketch for a "Flagellation of Christ" (*or a "Return of the Prodigal Son"*). Charcoal on light blue paper; 378 × 272 mm. Bibl.: Hadeln, pp. 31, 51, Plate 13; Tietze, 1648, p. 284; *id., Tint.*, Plate 73.

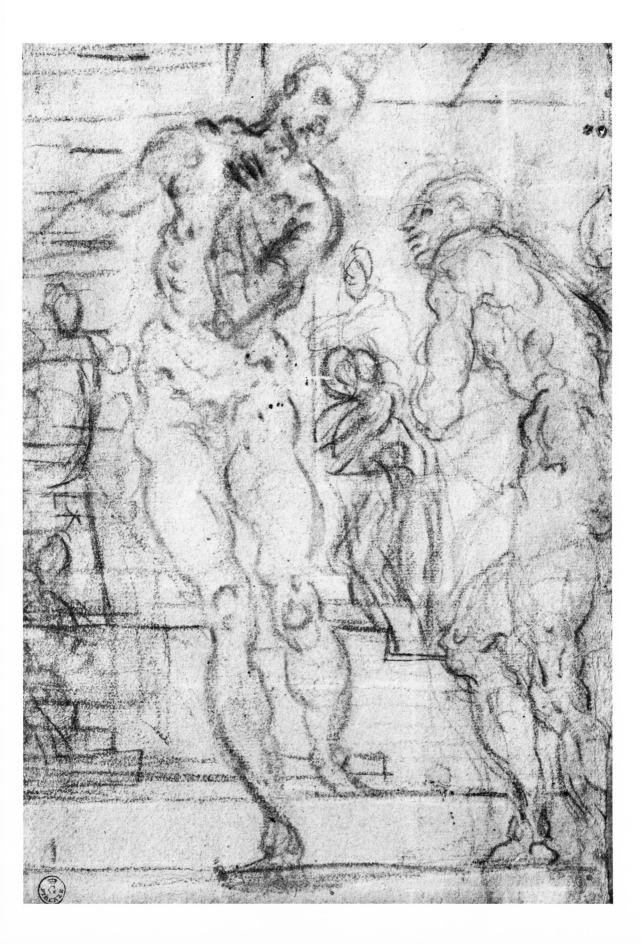

3

Study for a group of "Samson and the Philistines." This group is related to Sheet #5228 of the Berlin Kupferstichkabinett. Bibl.: A. Venturi, *Studi*, p. 310, Fig. 197; Hadeln, *Burl. Mag.*, LI, p. 102; Tietze, XCII, I—1559.

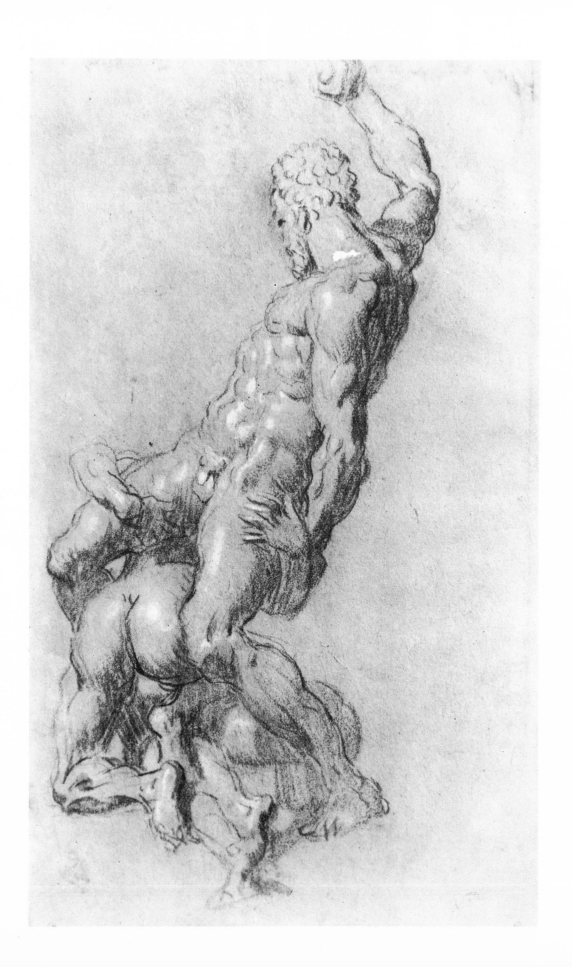

4

Study of a model for the "Giuliano de' Medici" of Michelangelo. On the verso is an analogous study of the same model. Bibl.: Hadeln, pp. 26, 53, Plate 7; Tietze, 1729.

OXFORD, CHRIST CHURCH, N. L. 2.

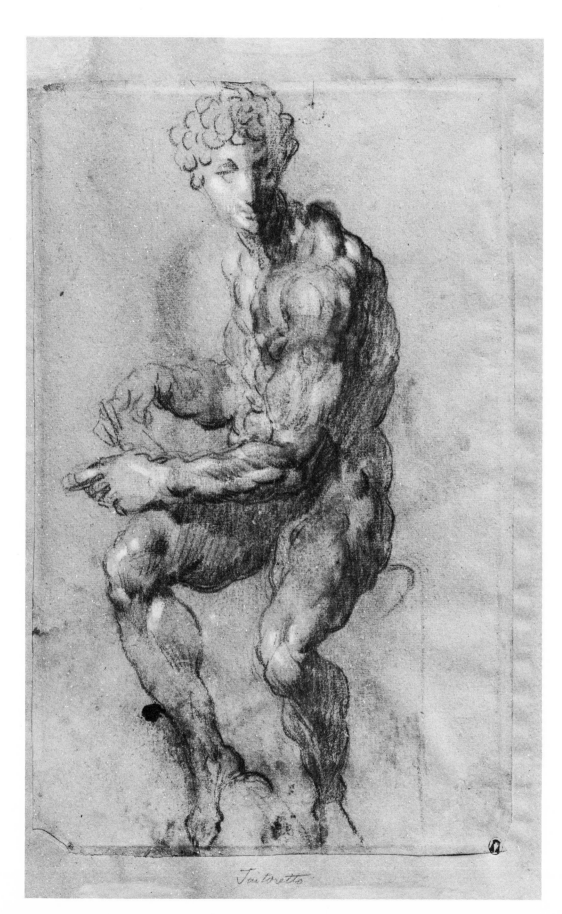

Tintoretto

5

Study of the head of the "Giuliano de' Medici" of Michelangelo. On the verso is an analogous study of the same head. Charcoal on grey paper; 353 × 233 mm. Bibl.: Hadeln, 24, 54, Plate 9.

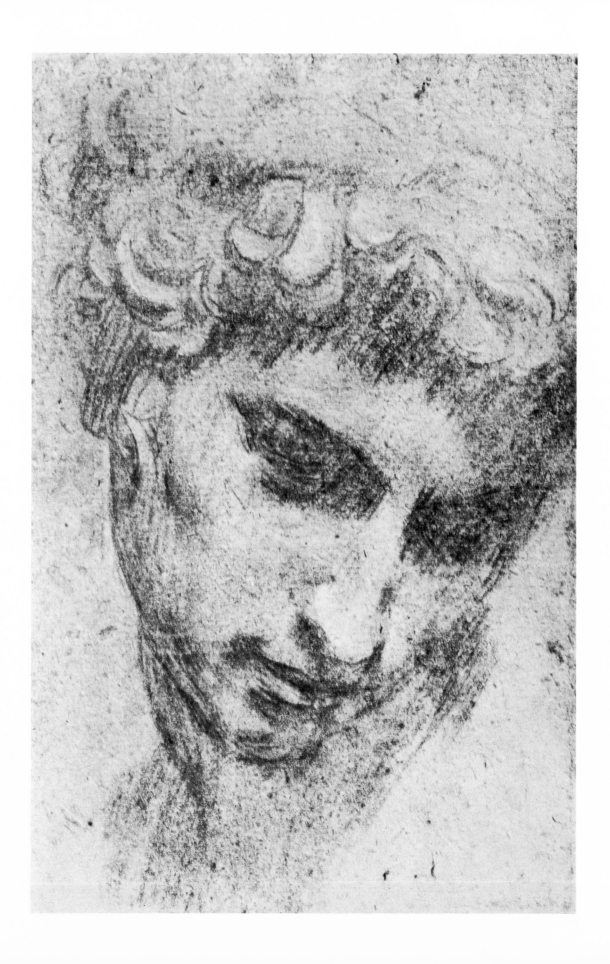

6

Study of a head said to be of Apollo. Bibl.: Tietze, Plate CXXIV, I, Index No. 1652.

FRANKFURT A. M., STÄDELSCHES KUNSTINSTITUT.

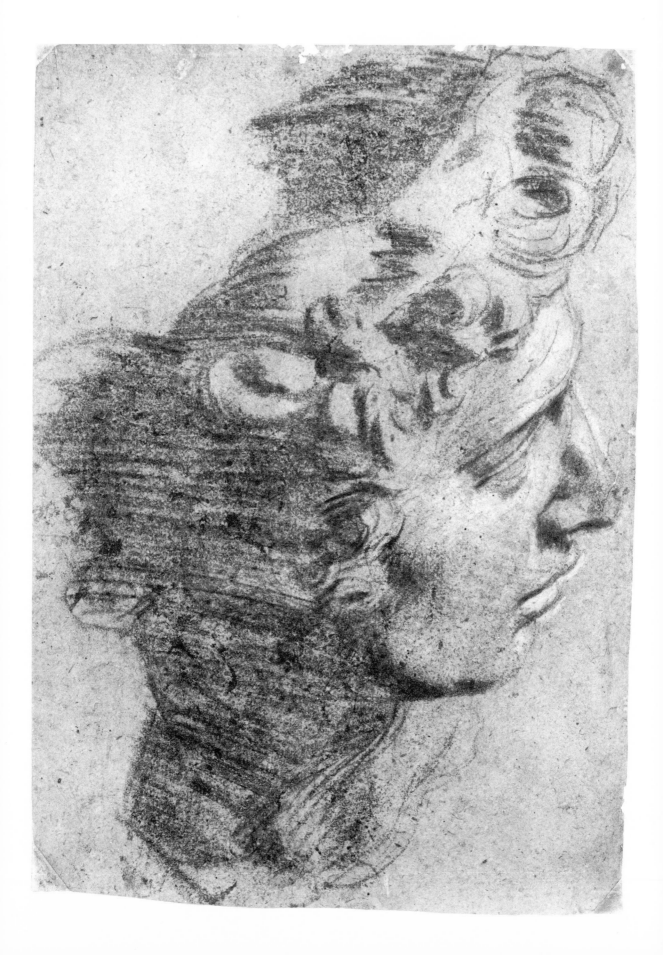

7

Study after a sculpture. Bibl.: Tietze, 1739; *id., Tint.*, Fig. 137.

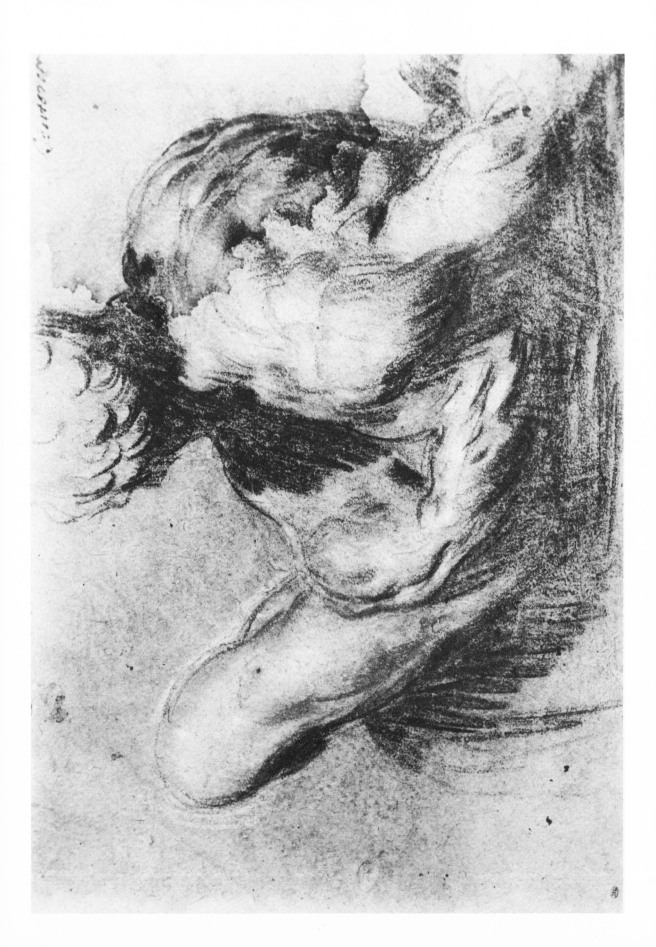

8

Study after the "Twilight" of Michelangelo. This is the recto; from the *Twilight*, seen from below, Tintoretto drew the figure for the fresco in the Casa Gussoni, now lost, but reproduced by Zanetti; cf. Coletti, Plate 56 A. Charcoal and chalk on light blue paper; 273 × 371 mm. On the verso is an analogous study. Bibl.: Hadeln, pp. 26, 52, Plate 6; Tietze, p. 284, Plate CXII, 2.

FLORENCE, UFFIZI, # 13048.

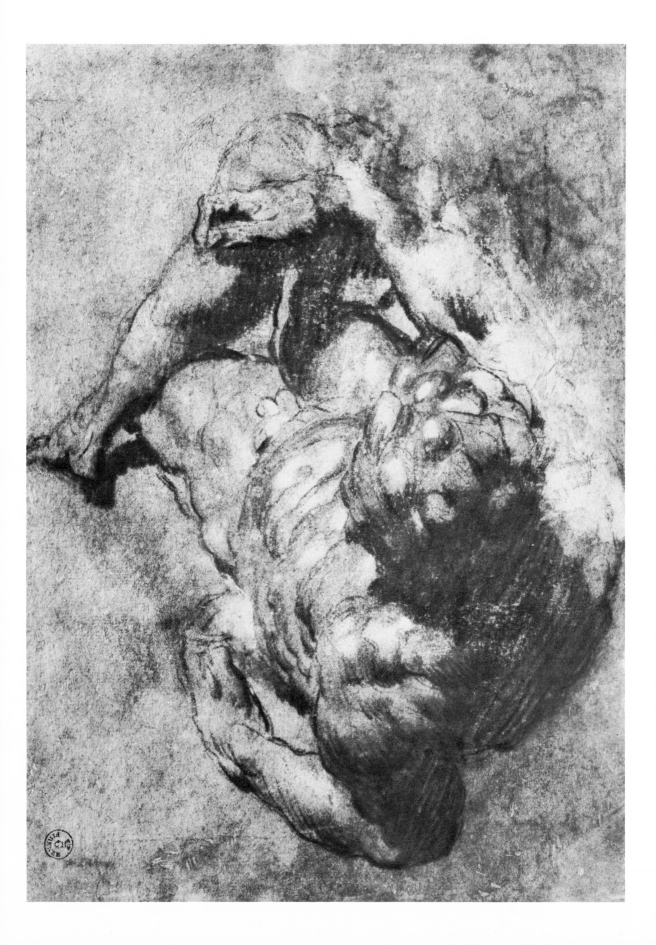

9

Study after the "Day" of Michelangelo. Bibl.: Hadeln, pp. 26, 53, Plate 5; Tietze, p. 1730; Coletti, p. 24 and Plate 56 B.

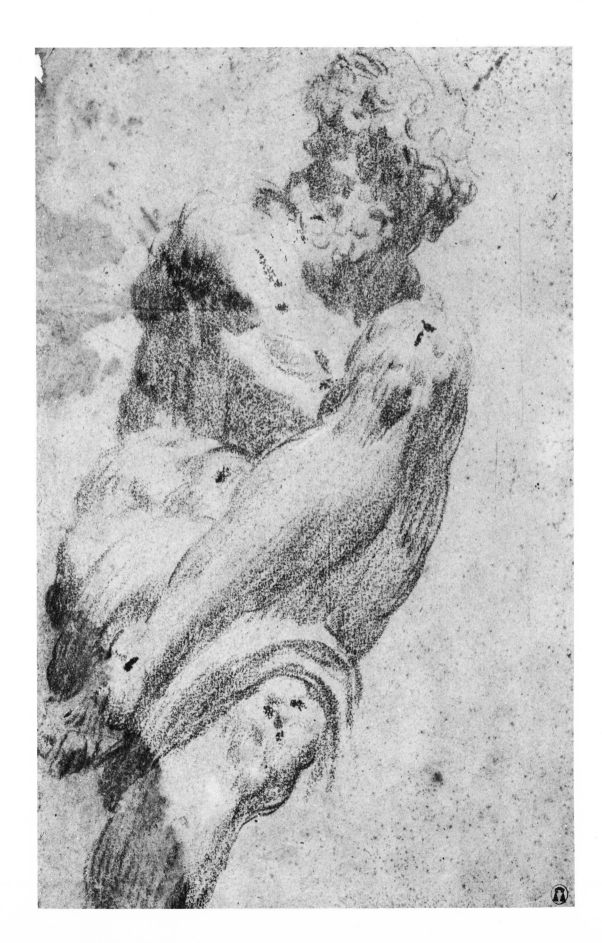

10

Study for the soldiers throwing dice in the "Crucifixion" of the Galleria dell' Accademia, Venice.
About 1560. Charcoal heightened with white lead on light blue paper; 215 × 430 mm. The
sheet is formed of two pieces glued together. Bibl.: Hadeln, pp. 33, 50, 51, 57, Plate 60;
Tietze, pp. 283, 1632; *Catal. dell' Acc. Venezia,* 1949, p. 97, No. 213.

FLORENCE, UFFIZI, # 13005,

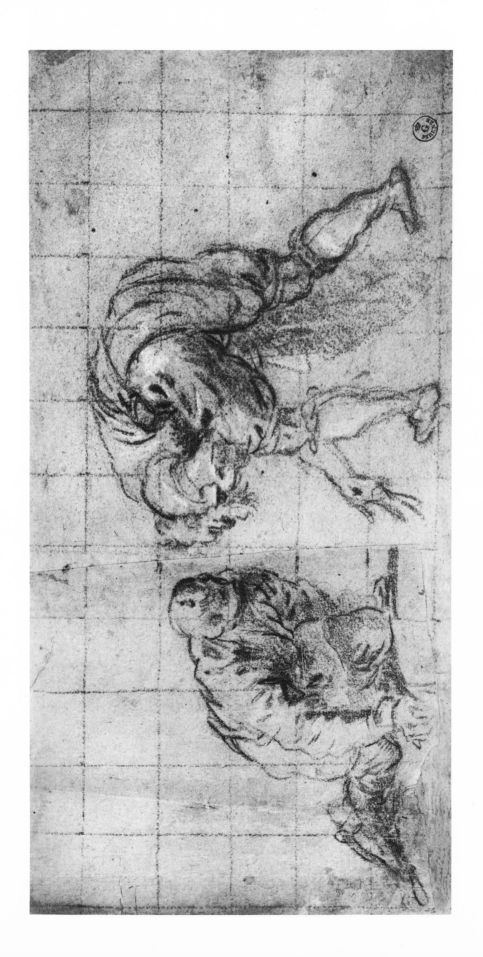

11

Study for a figure in "The Wedding Feast at Cana," Venice, Church of Santa Maria della Salute, dated 1561. Charcoal on light grey-blue paper; 261 × 395 mm. Bibl.: Hadeln, pp. 37, 51, 57, Plate 62; Tietze, pp. 283, 1634.

FLORENCE, UFFIZI, # 13000.

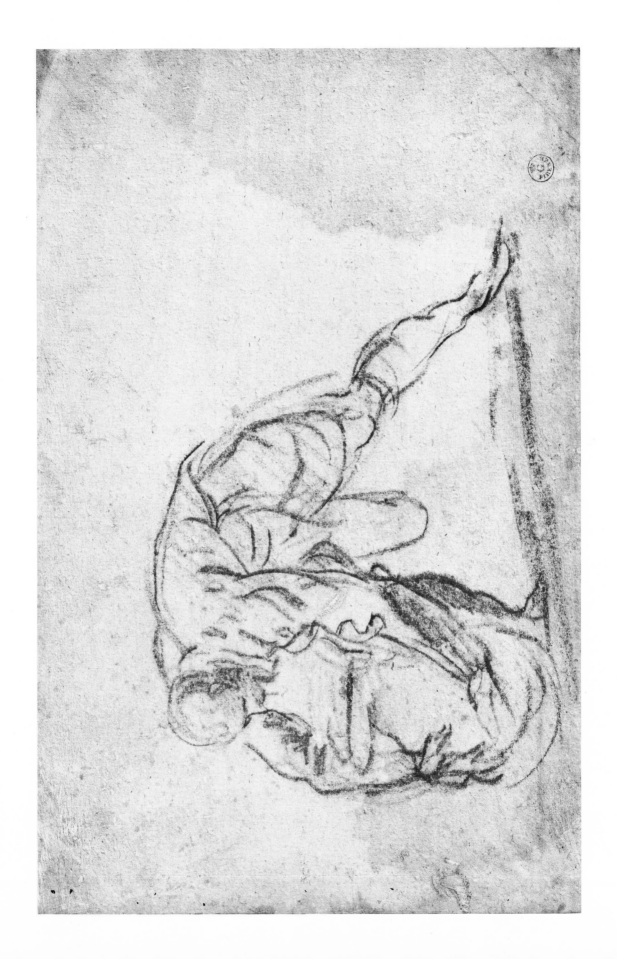

12

Study for a nude in "The Worship of the Golden Calf" in the Madonna dell'Orto, Venice. After 1560. Charcoal with chalk highlights on light blue paper; 287 × 207 mm. Cf. analogous drawing, Uff. # 12930. Bibl.: Hadeln, pp. 34, 36, 42, 48, 57; Tietze, p. 280, 1591.

FLORENCE, UFFIZI, # 1834.

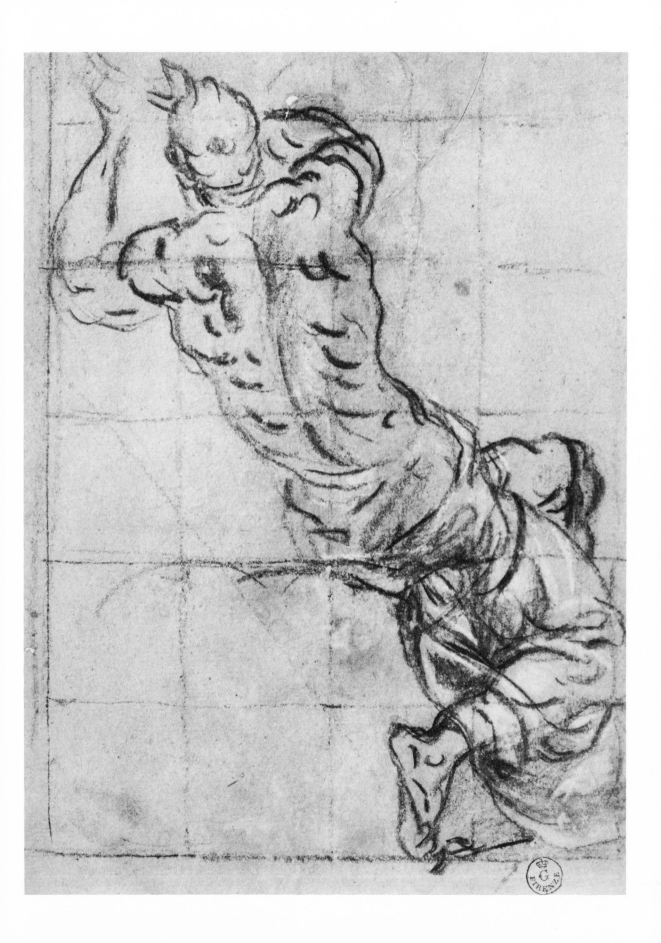

13

Study for "The Washing of the Feet" in the Church of Santo Stefano, Venice. Charcoal on untinted paper; 345 × 395 mm. Probable date of the painting 1565–70. Done when the master was about fifty years old; drawing contemporary with the work at San Rocco. Bibl.: Hadeln, pp. 33, 50, 57, Plate 15; Tietze, pp. 283, 1632.

FLORENCE, UFFIZI, # 12999.

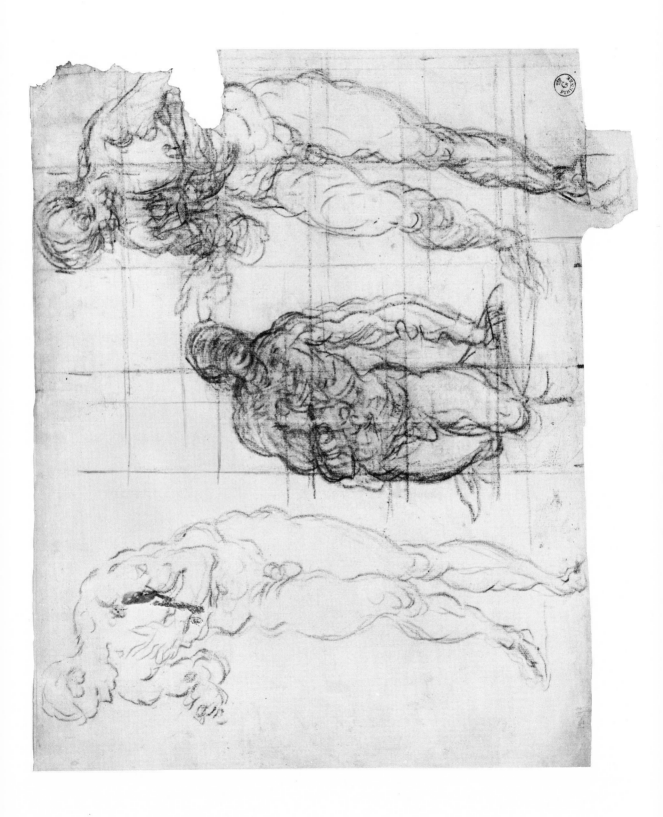

14

Study of a nude for "The Way to Calvary" in the Scuola di San Rocco, Venice. Charcoal on light grey paper; 378 × 201 mm. Bibl.: Hadeln, p. 51, Plate 27; Tietze, pp. 284, 1640.

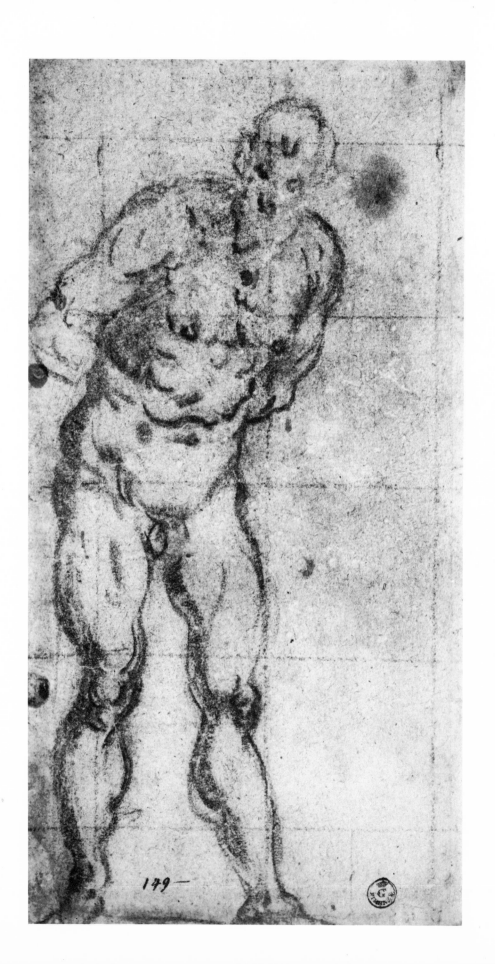

149—

15

Study for the Eve in the "Christ in Limbo" in the Church of San Cassiano, Venice. About 1568. Charcoal with white highlighting on light blue paper; 250 × 148 mm. Bibl.: Hadeln, Plate 28; Tietze, p. 282, Plate CIV. Approximate date of the painting: Galliccioli, 1568; Lorenzetti, *Guida*, 1568?.

FLORENCE, UFFIZI, # 12977.

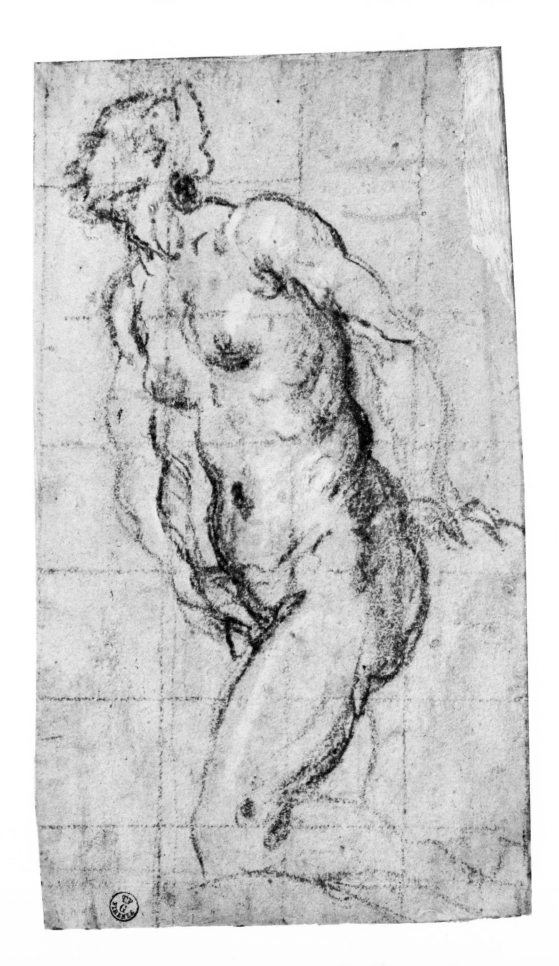

16

Study for the St. John in "The Baptism of Christ" in the Church of San Silvestro, Venice. About 1568—or 1580? Charcoal on light blue paper; 390 × 265 mm. Bibl.: Hadeln, pp. 43, 49, 57, Plate 35; Tietze, pp. 281, 1598.

FLORENCE, UFFIZI, # 12943.

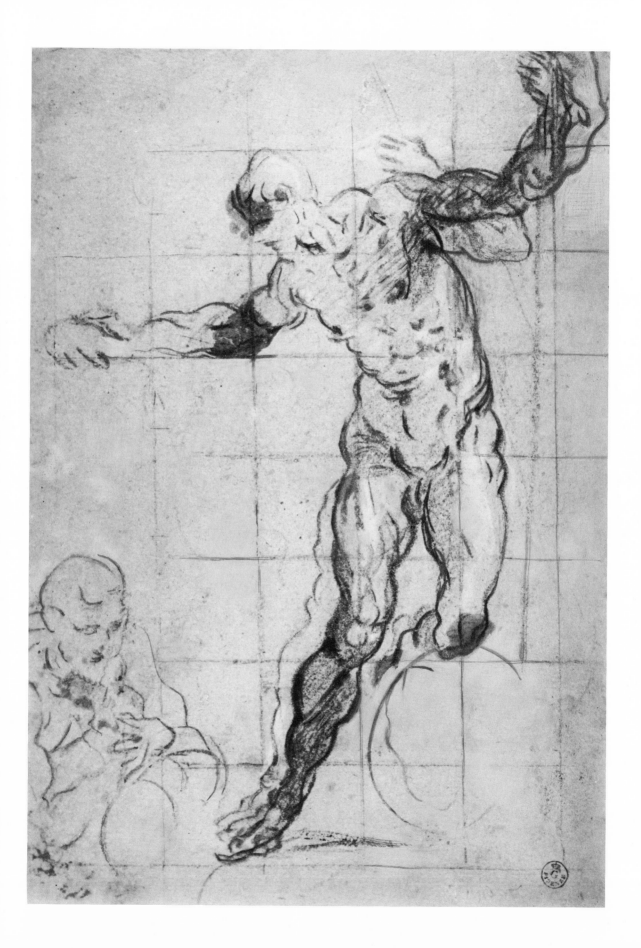

17

Study of a nude for the Christ of "The Baptism of Christ" in the Church of San Silvestro, Venice. Charcoal on white paper; 305 × 196 mm. Compare the following drawing. Bibl.: Tietze, Plate CVII, p. 3; Hadeln, pp. 49, 57, Plate 34; *Catal. Mostra del Tintoretto*, Venice, 1937, p. 217.

FLORENCE, UFFIZI, # 12961.

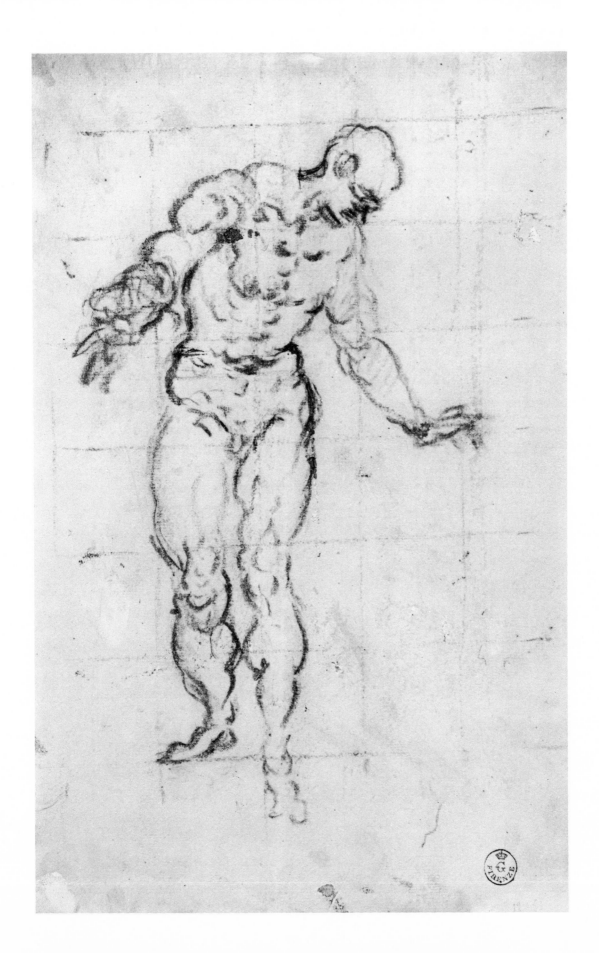

18

Study of drapery. Charcoal with touches of chalk on light blue paper. Bibl.: Hadeln, pp. 36, 54, Plate 57; Tietze, pp. 291, 1745.

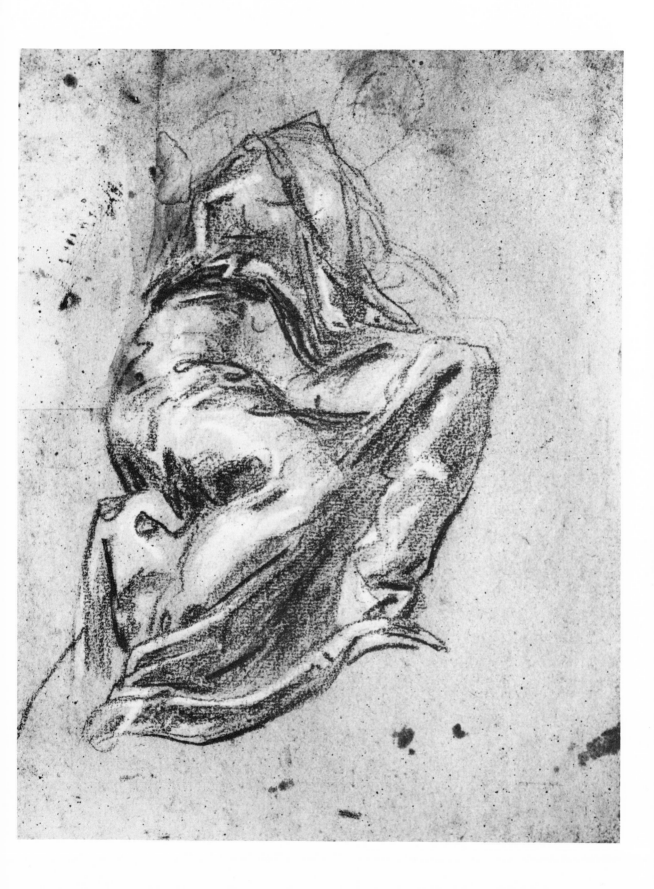

19

Study for a "Kneeling Bishop." Charcoal heightened with white lead on light blue paper; 294 × 200 mm. Bibl.: Hadeln, pp. 36, 51, Plate 59; Tietze, pp. 283, 1636.

FLORENCE, UFFIZI, # 13013.

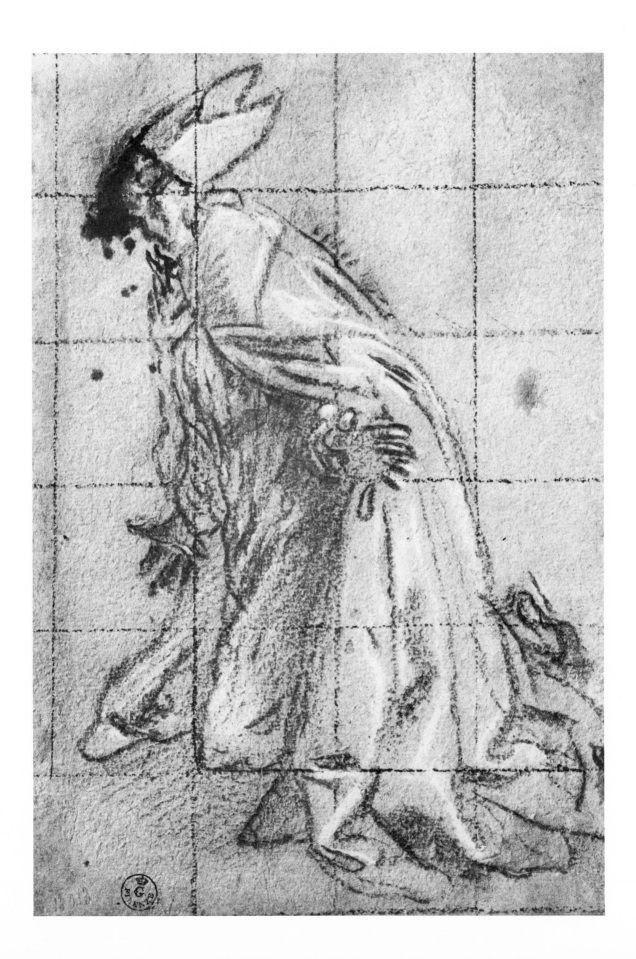

20

Study for a "Philosopher" in the Biblioteca Marciana. About 1570–75. Charcoal with white lead highlighting on grey paper; 298 × 201 mm. Bibl.: Hadeln, pp. 35, 50, 57, Plate 56; Tietze, pp. 283, 1625; *id., Tint.*, Plate 159.

FLORENCE, UFFIZI, # 12986.

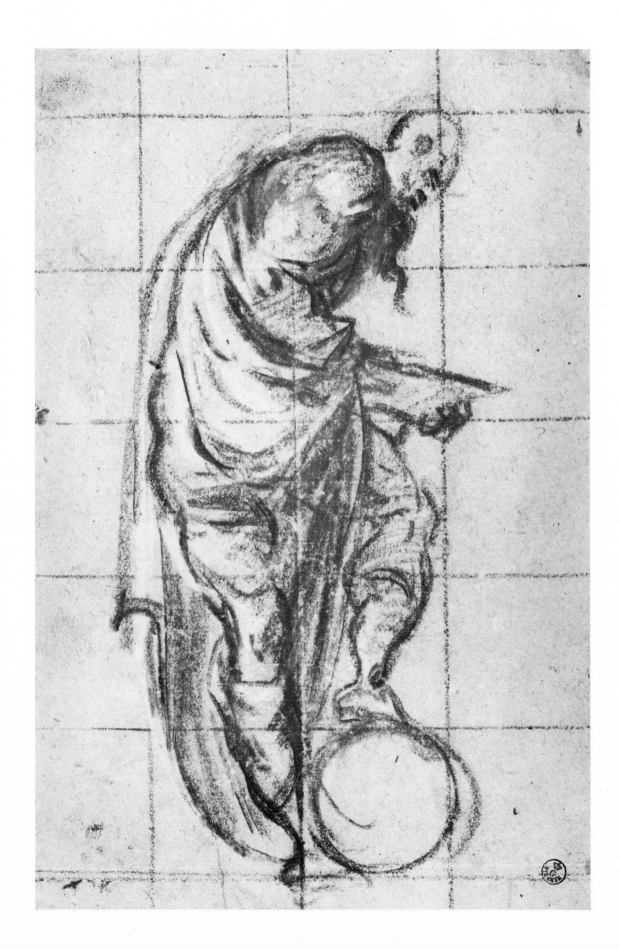

21

Study of a nude. Charcoal on grey paper; 379 × 227 mm. Bibl.: Hadeln, p. 52, Plate 26; Tietze, pp. 284, 1648.

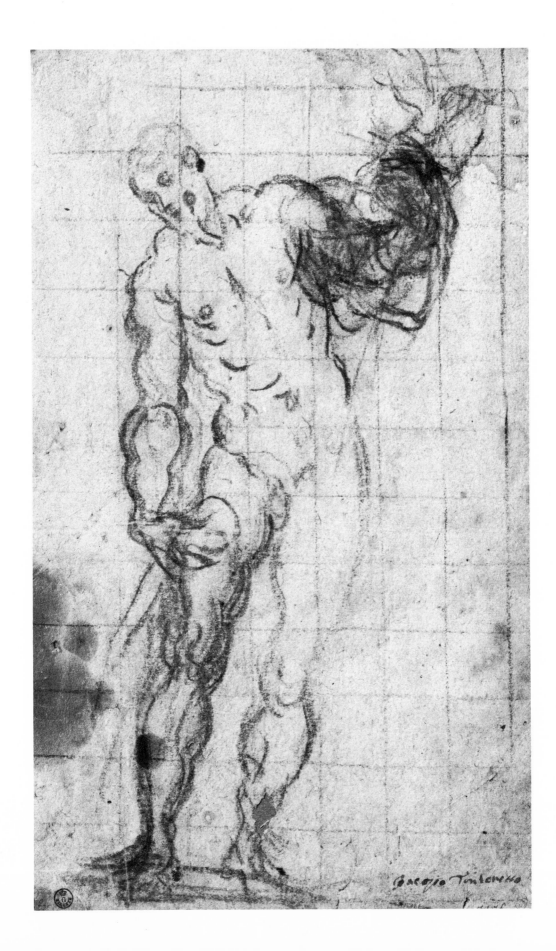

Study of a nude. Charcoal on white paper; 271 × 197 mm. Bibl.: Hadeln, p. 50, Plate 37; Tietze, pp. 283, 1593.

FLORENCE, UFFIZI, # 12985.

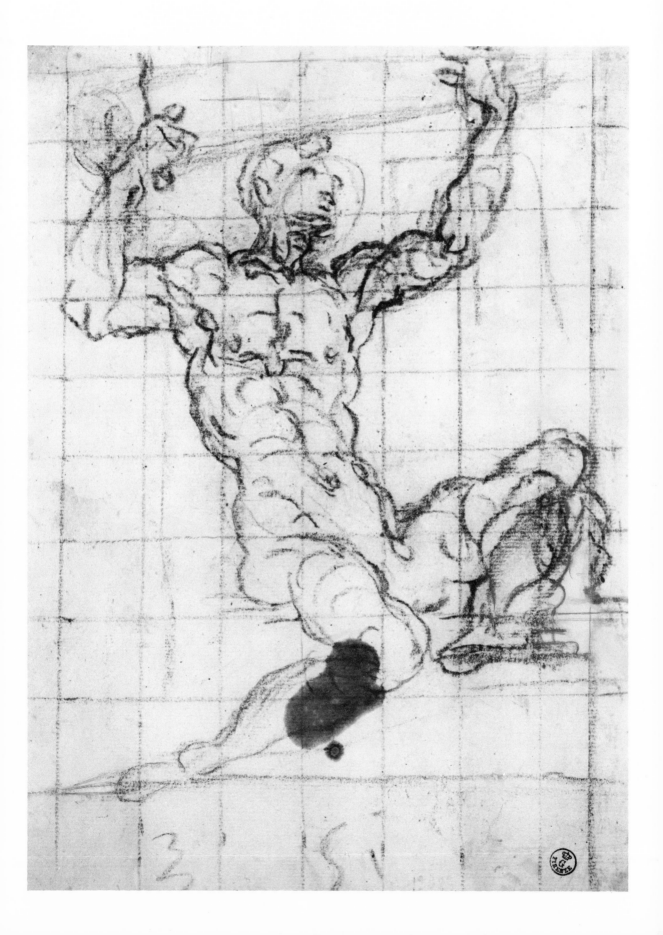

23

Study of a nude for the Christ at the Column in "The Flagellation of Christ" in the Vienna Kunsthistorisches Museum. Charcoal on untinted paper. Bibl.: Tietze, pp. 281, 1603, Plate CIX, 4.

FLORENCE, UFFIZI, # 12952.

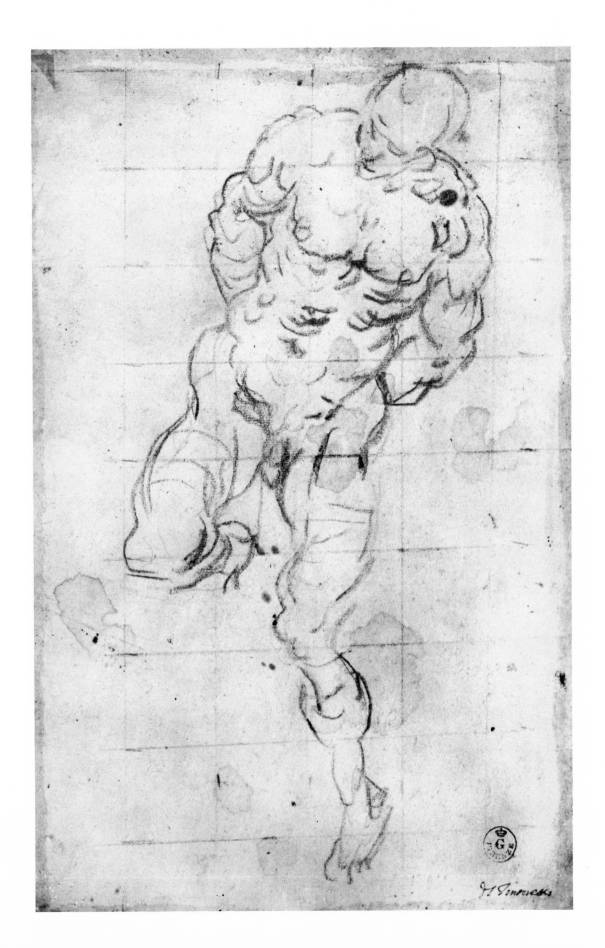

24

Study of a seated nude. Crayon on light blue paper; 242 × 142 mm. Bibl.: Hadeln, pp. 35, 42, 47, Plate 21; Tietze, pp. 279, 1578.

DARMSTADT, LANDESMUSEUM, N.A.E. 14.

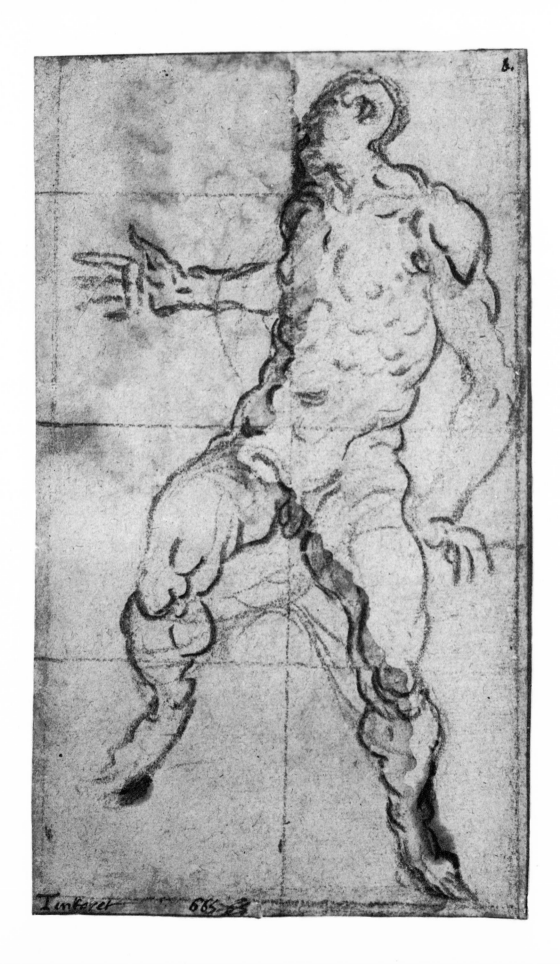

8.

Tintoret 665

25

Study for a running figure. Charcoal on grey paper; 225 × 230 mm. Bibl.: Hadeln, p. 50, Plate 66; Tietze, pp. 283, 1626.

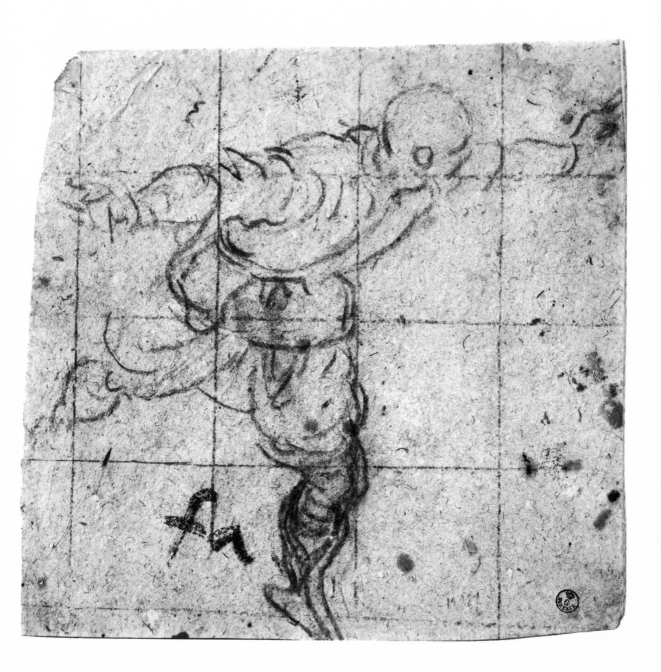

Study of a costumed model. Charcoal on white paper; 245 × 114 mm. Bibl.: Hadeln, p. 48, Plate 65; Tietze, pp. 280, 1587.

FLORENCE, UFFIZI, # 12923.

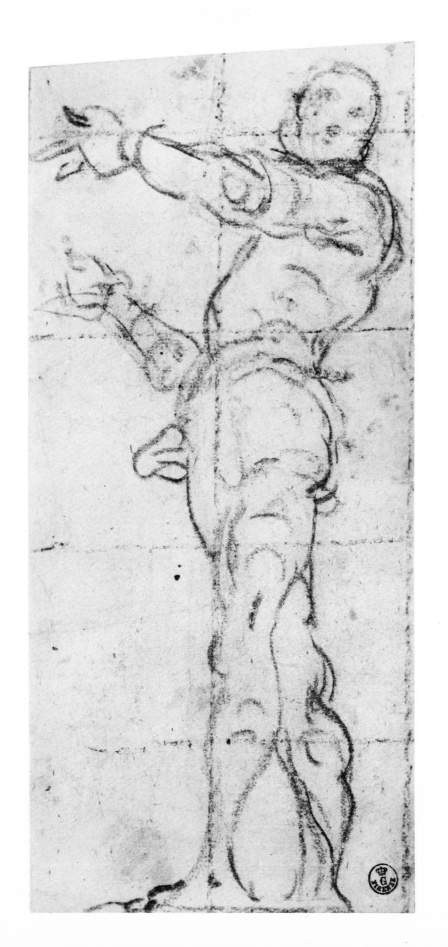

27

Study for a man in armor in "*The Investiture of G. F. Gonzaga with the Marquisate of Mantua by the Emperor Sigismund*" *in the Munich Pinakothek.* Charcoal on light blue paper; 347 × 167 mm. Bibl.: Hadeln, pp. 36, 52, 57, Plate 70; Tietze, p. 284, 1642.

FLORENCE, UFFIZI, # 13041.

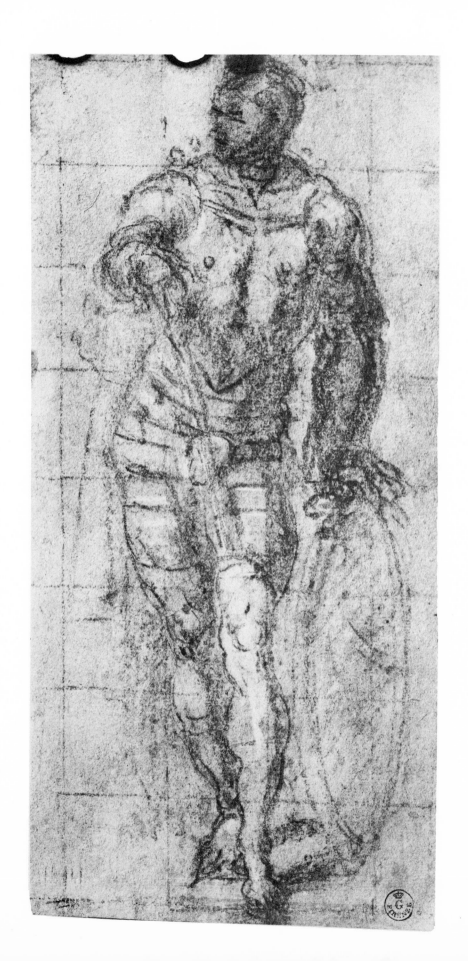

28

Study for a "Warrior." Charcoal on white paper; 332 × 224 mm. Bibl.: Hadeln, pp. 34, 50, Plate 52; Tietze, p. 282, 1616.

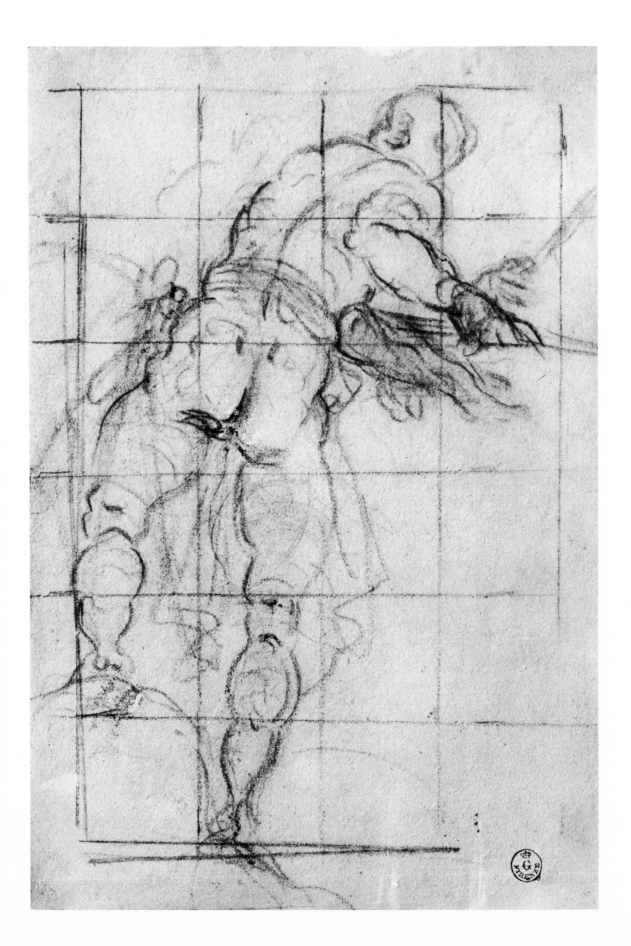

29

Study for a "Rower." Charcoal on white paper; 259 × 219 mm. Bibl.: Hadeln, pp. 36, 44, 54, Plate 69; Tietze, p. 291, 1748 bis.

ROME, GALLERIA CORSINI, GABINETTO DEI DISEGNI, # 125578.

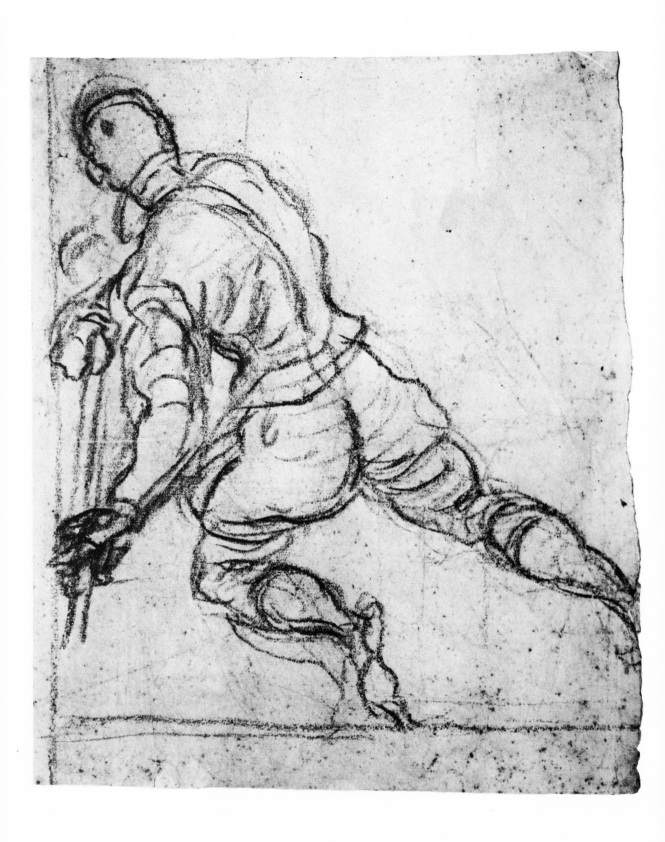

30

Study for the standard-bearer in "The Battle of Gallipoli" on the ceiling of the Sala del Maggior Consiglio in the Doges' Palace, Venice. (The caricature at the right is not by Tintoretto.) Charcoal on white paper; 278 × 200 mm. Bibl.: Hadeln, pp. 24, 48, 58, Plate 42; Tietze, p. 281, 1593; D'Albanella, *Venet. Drawings*, The Hague, 1950, Plate 61.

FLORENCE, UFFIZI, # 12932.

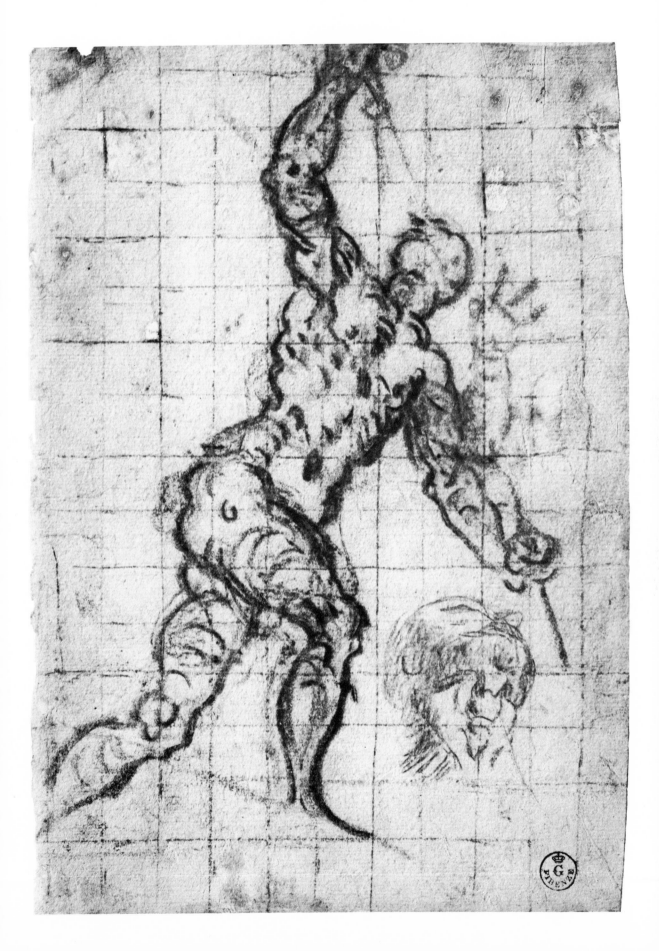

31

Archer, study for "The Battle of Zara," Venice, Doges' Palace, Sala dello Scrutinio. About 1584–87. Charcoal on brown paper; 322 × 207 mm. Bibl.: Hadeln, pp. 34, 43, 50, 58, Plate 48; Tietze, p. CXI, 1.

FLORENCE, UFFIZI, # 12968.

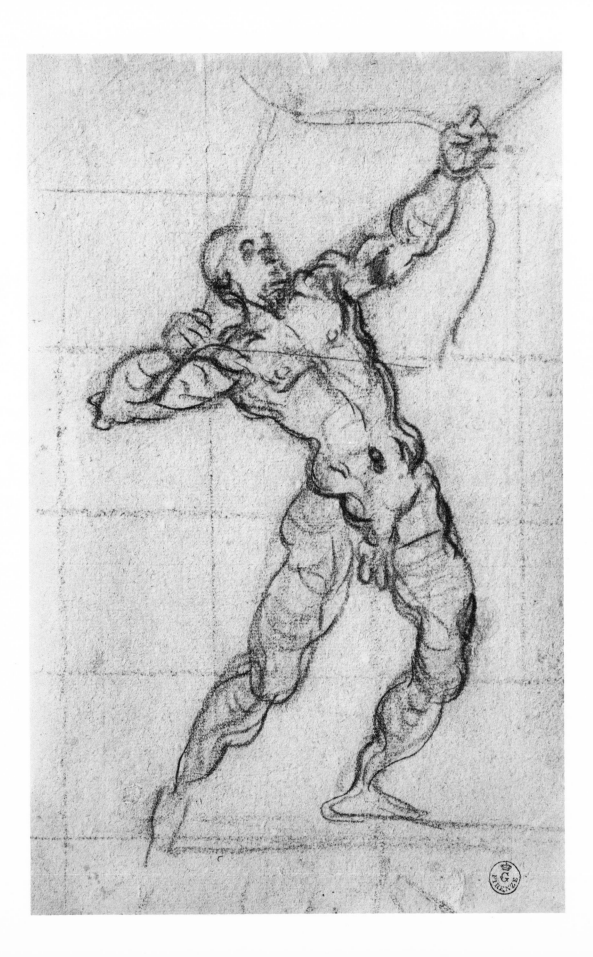

32

Archer, study for "The Battle of Zara," Venice, Doges' Palace, Sala dello Scrutinio. About 1584–87. Charcoal on brown paper; 366 × 220 mm. Bibl.: *Disegni degli Uffizi*, Olschki, F., II, 25; Hadeln, pp. 34, 43, 48, 58, Plate 47; *Catal. Mostra del Tintoretto*, Venice, 1937, p. 216; Coletti, T., Plate 131-*b* B; Tietze, p. 280, 1590.

FLORENCE, UFFIZI, # 12929

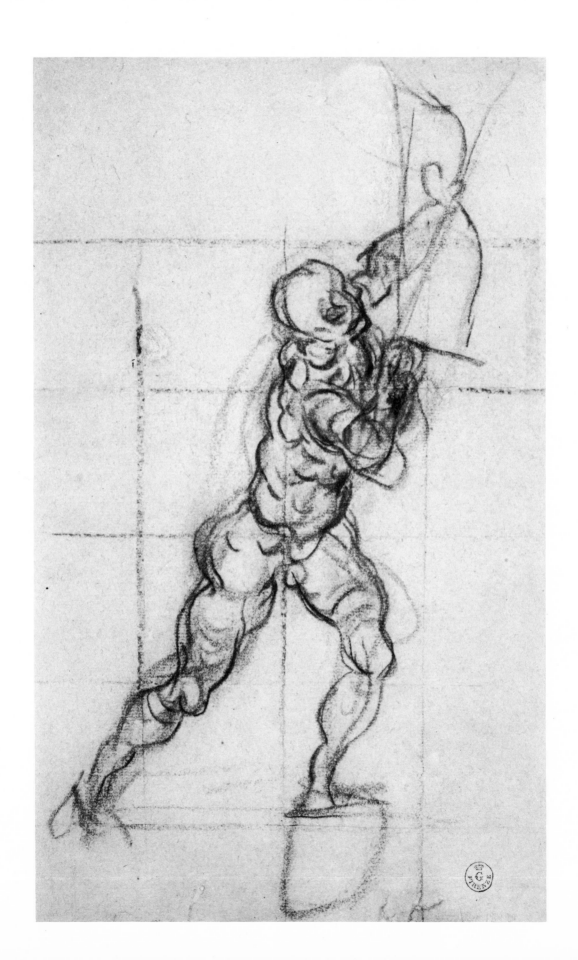